Art Around the World

by Margie Burton, Cathy French, and Tammy Jones

People live all around the world.

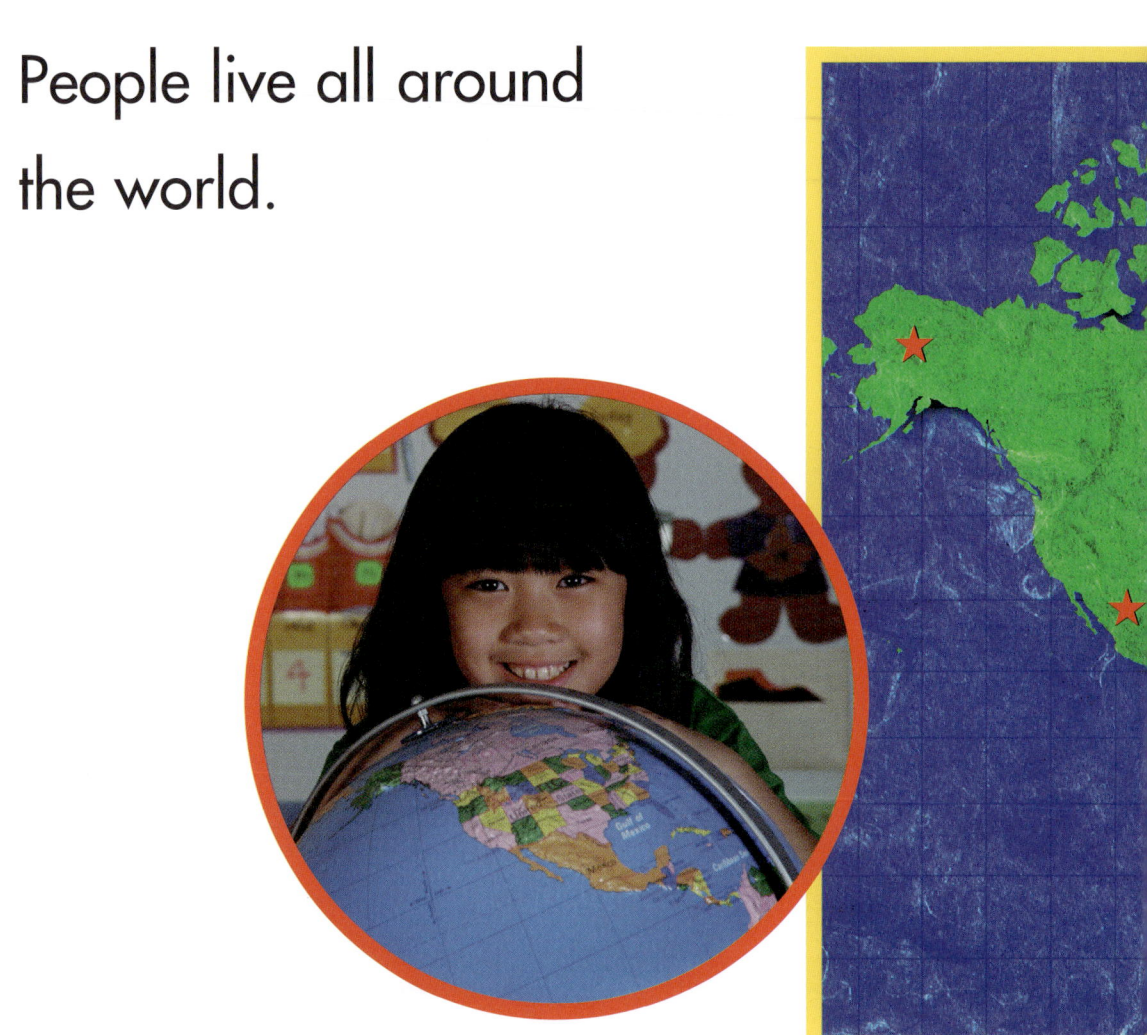

They like to make many kinds of things for art.

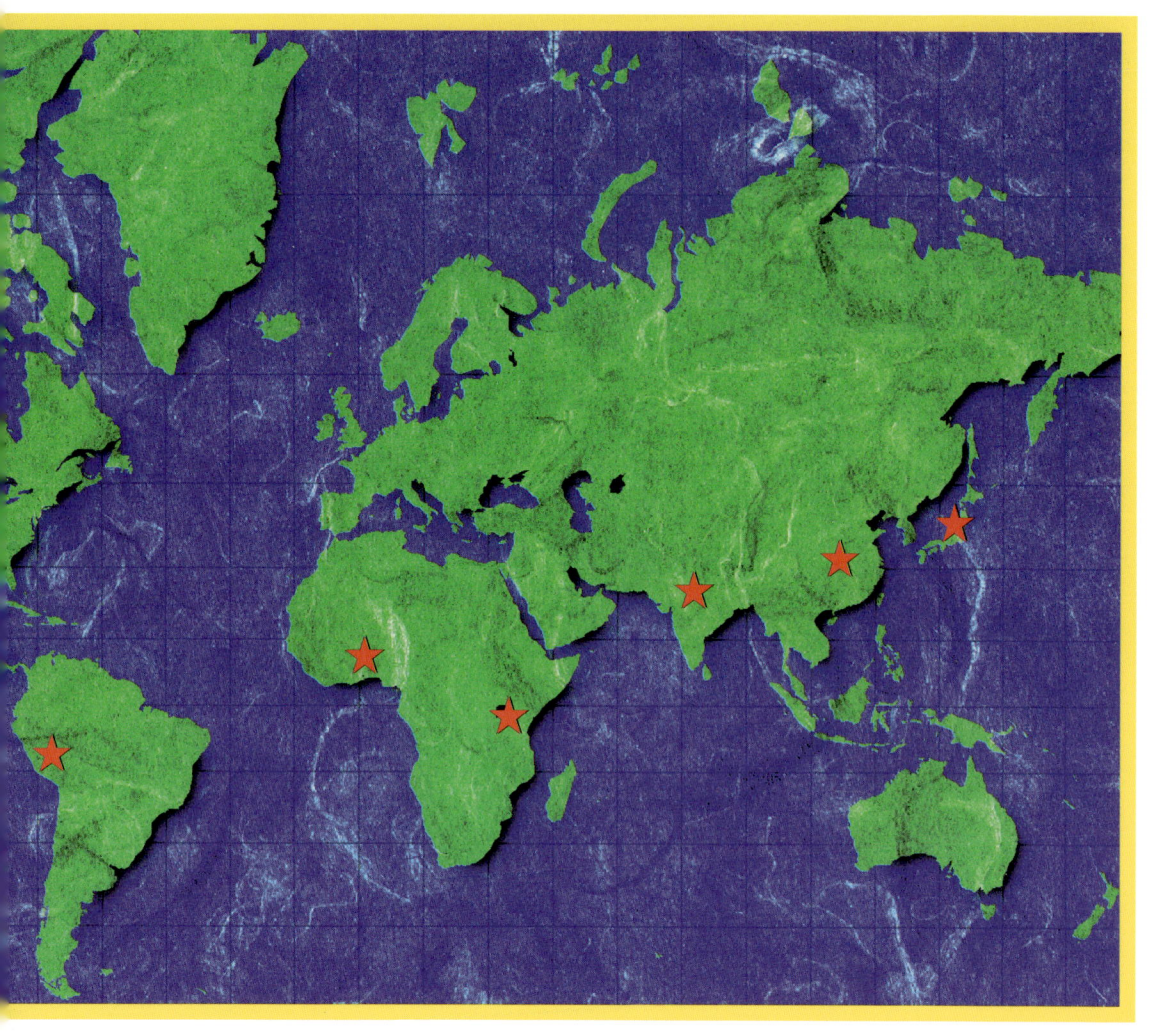

3

India

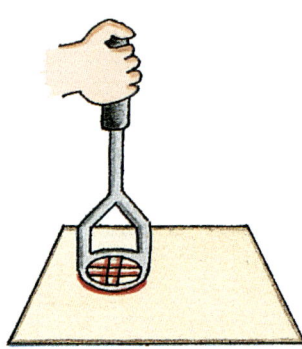

They make pretty cloth.

They use a stamping tool to make the cloth look pretty.

The stamps are put into
the ink and stamped
onto the cloth to
make it look pretty.
They use the same stamp
over and over and over.

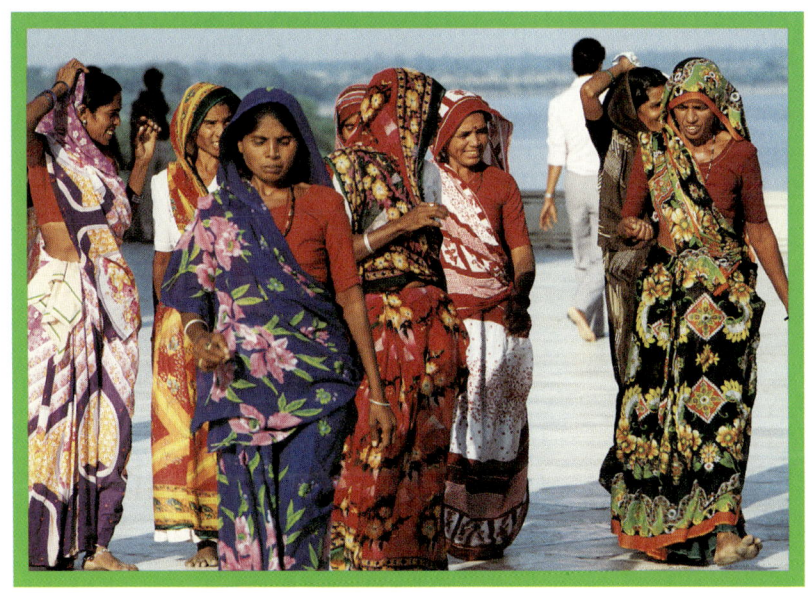

In India, they stamp their cloth to make it look pretty.

Here is how you can make a card at home using a stamping tool:

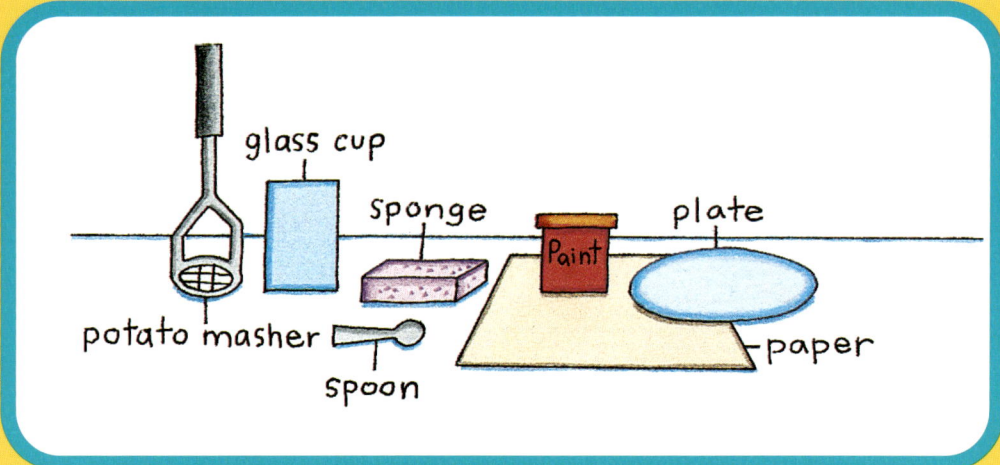

1. Get some paper and tools from around the house.

2. Put some paint on a plate and spread it around with a spoon.

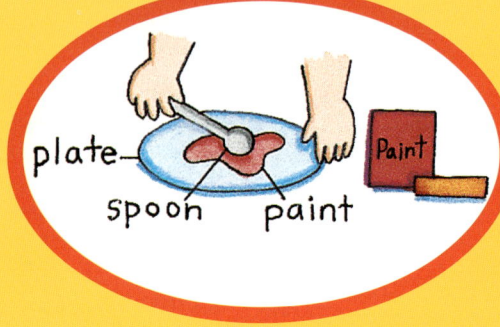

3. Dip the tool into the paint. Do not get too much paint onto the tool!

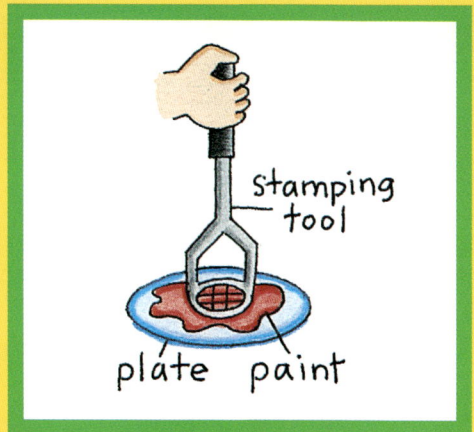

4. Use the tool to stamp your paper.

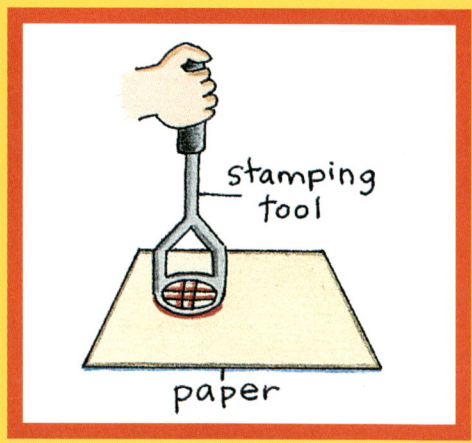

5. Keep stamping over and over.

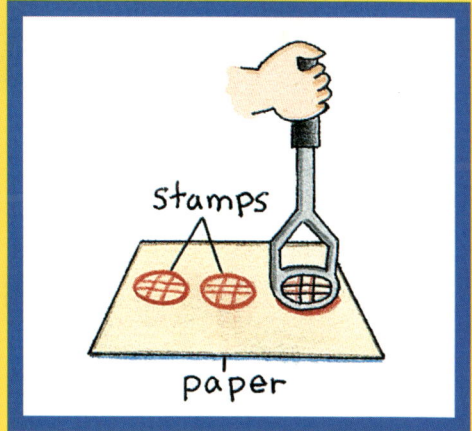

Ivory Coast

They like to make masks.

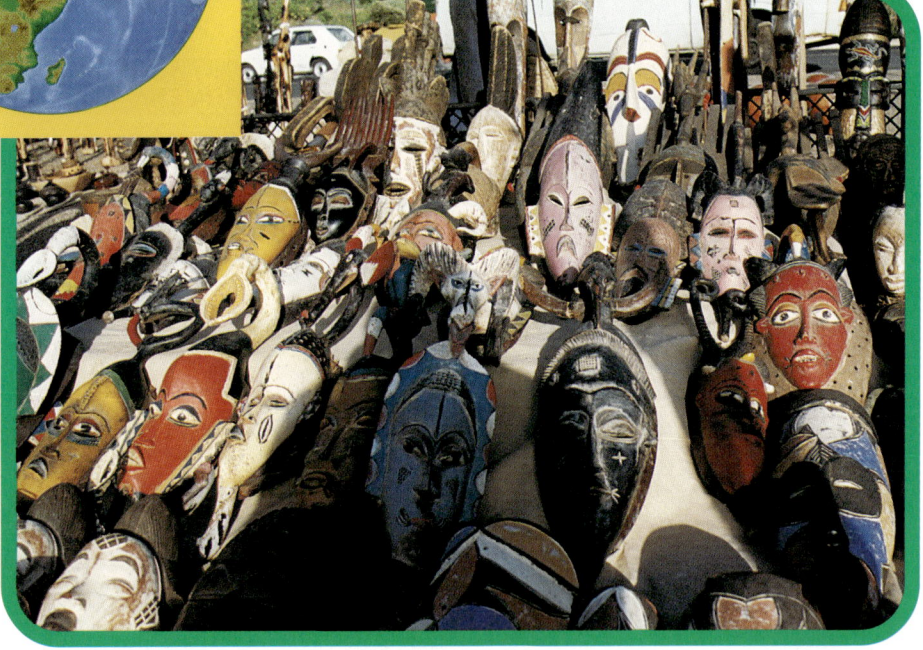

They make them from trees. They use the wood from a tree to carve a mask.

They like to make baskets.

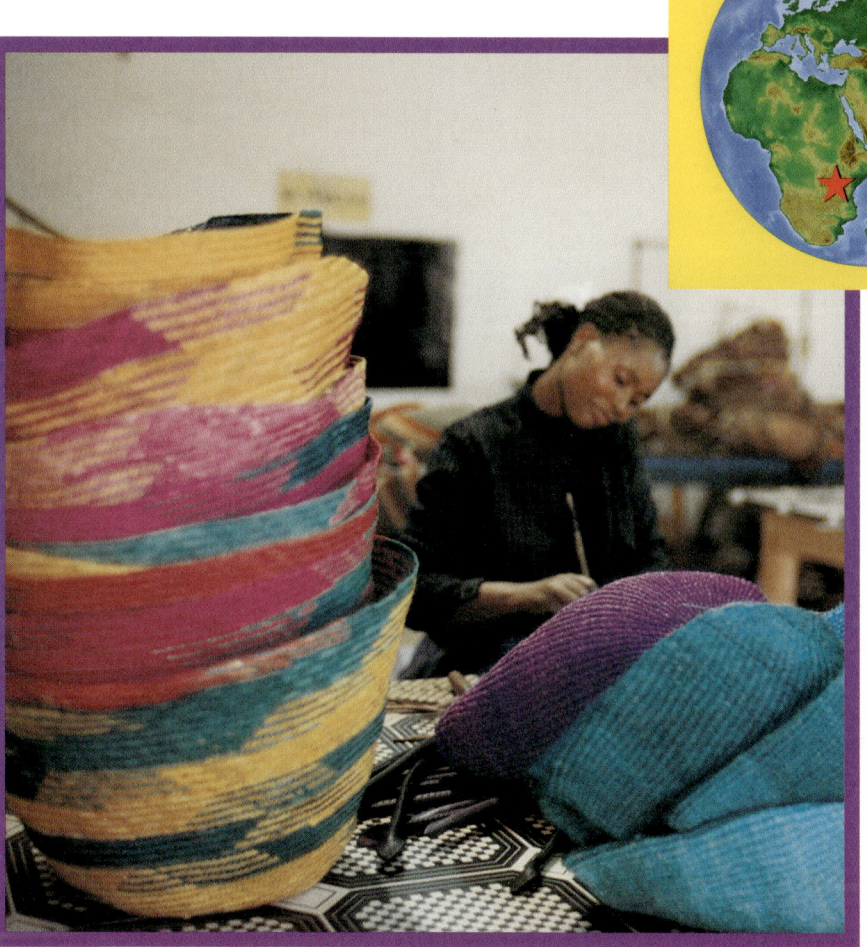

They use strands of grass to make the baskets.

Japan

They make pretty things out of paper.

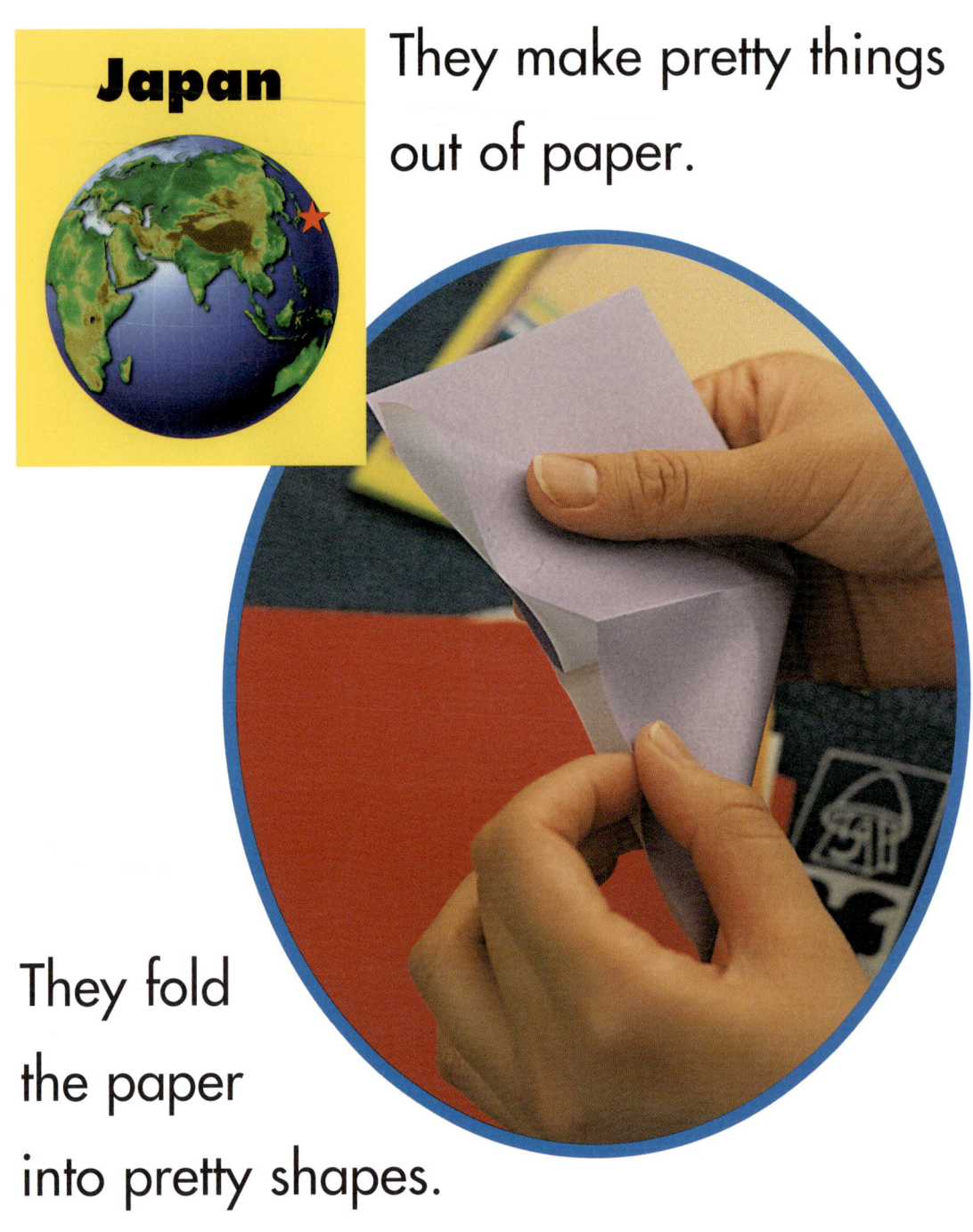

They fold the paper into pretty shapes.

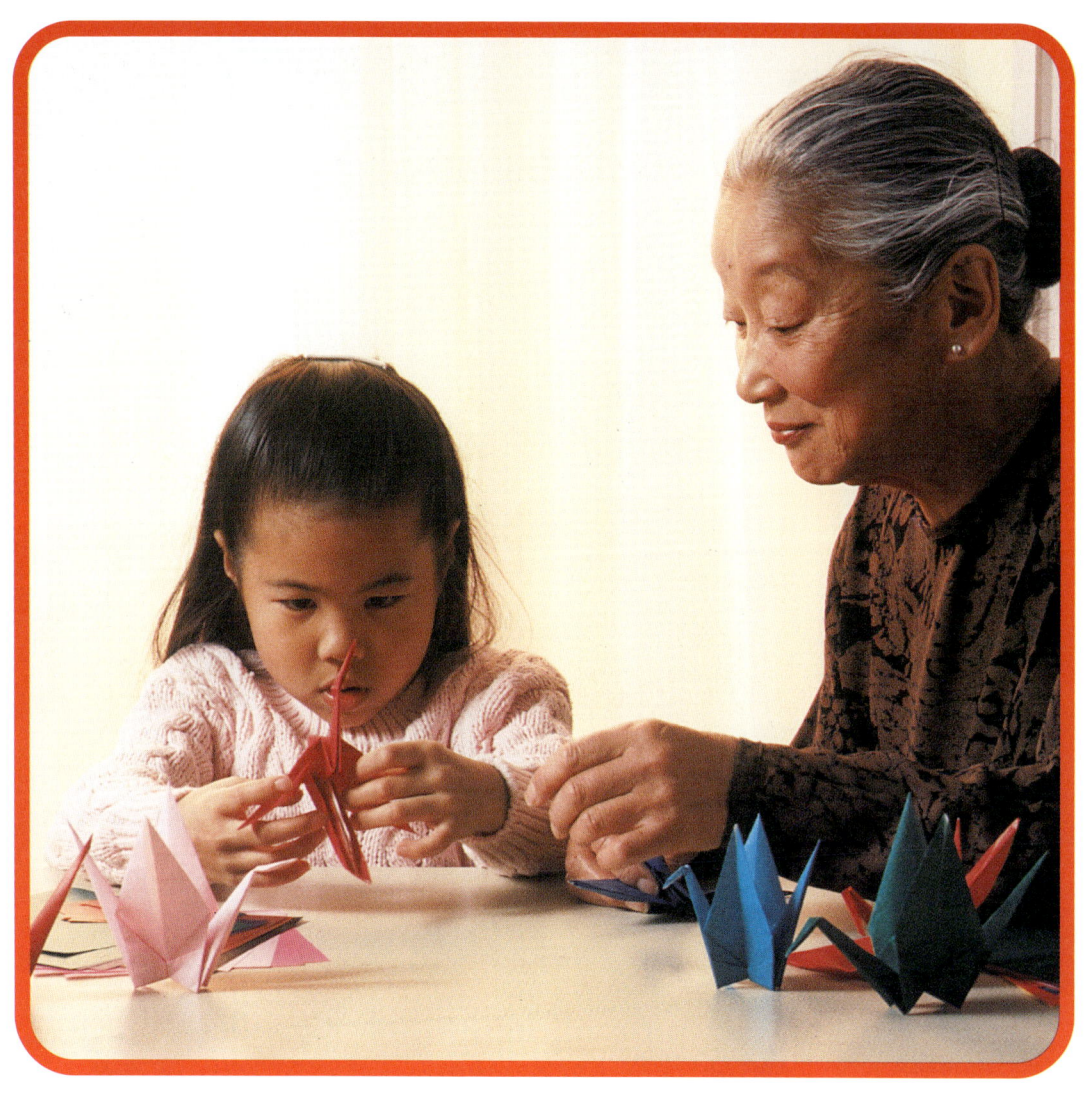

In Japan, paper folding is called origami.

China

They make things out of cloth.

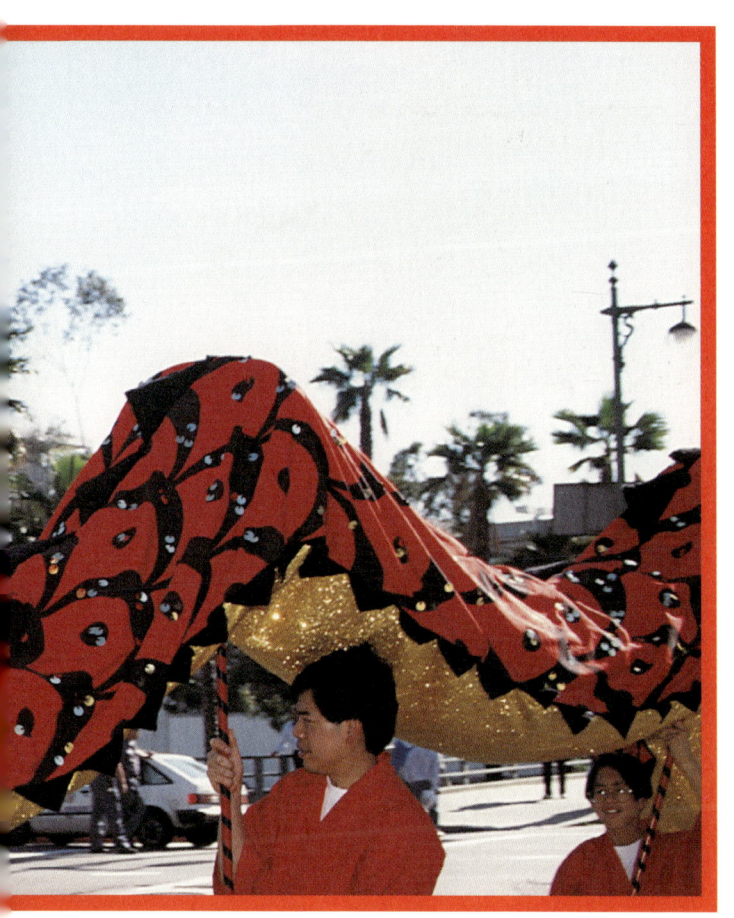

They fly their kites on Chinese New Year.

They use cloth to make their kites. This kite looks like a dragon.

Peru

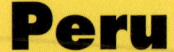

They make pretty belts.

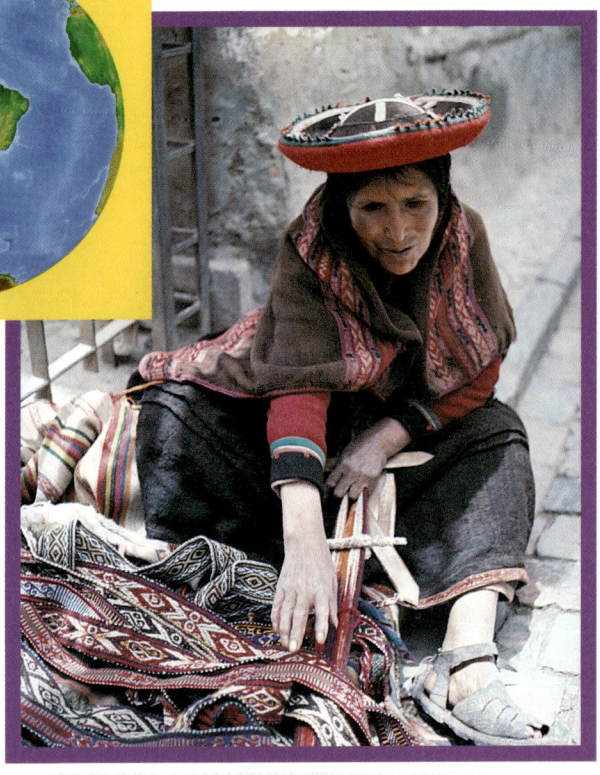

They use yarn to make the belt. They take the strands and go in and out to make the belt.

They make pretty cups from clay.

They shape the cups and bake them.
Then, the cups are painted.

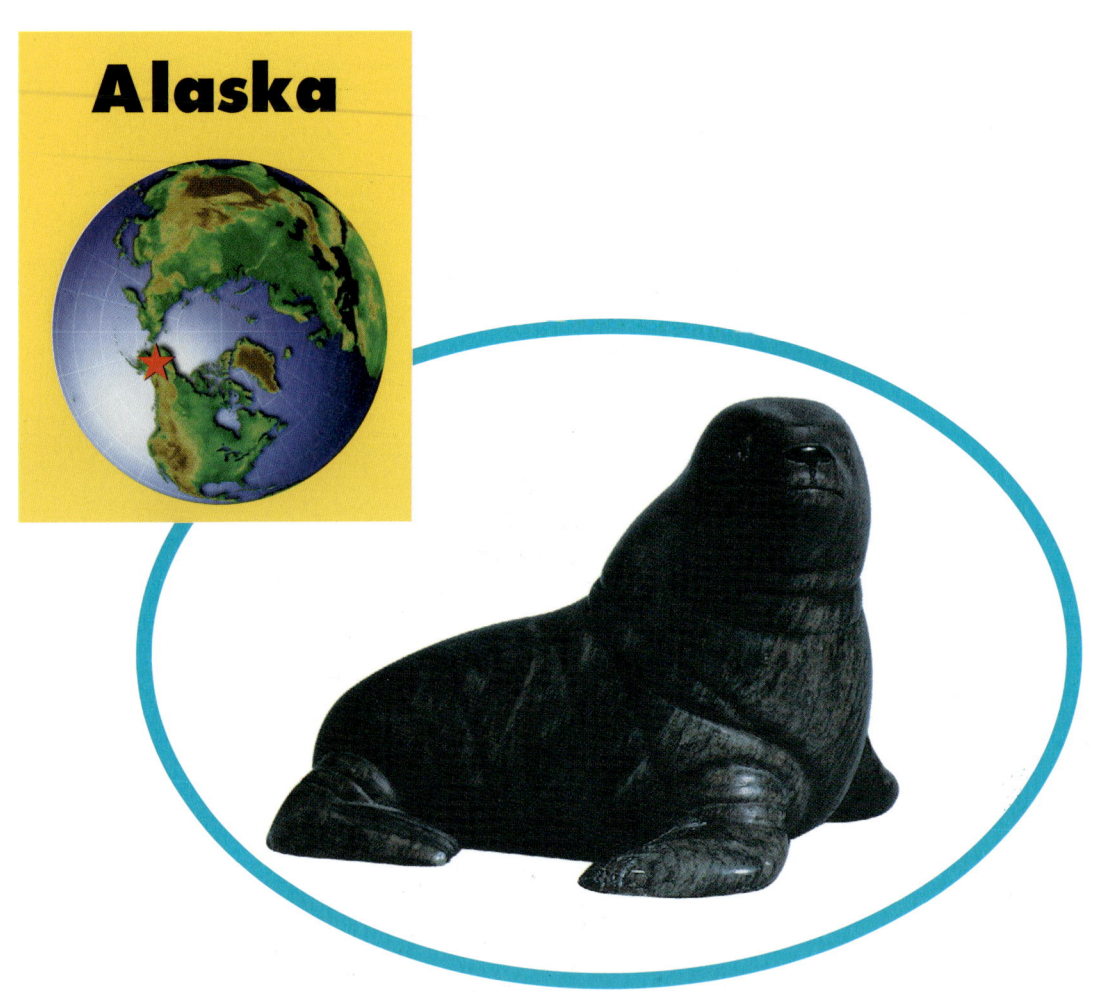

They carve animals from a stone.